D0381996

This little book belongs to

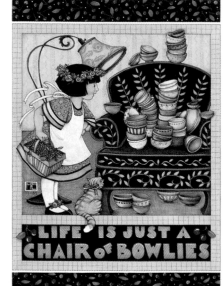

LIFE IS JUST A CHAIR OF BOWLIES

Life Is Just a
Chair of Bowlies

Illustrated by
Mary Engelbreit

Andrews and McMeel
A Universal Press Syndicate Company
Kansas City

ISBN: 0-8362-4615-2

Life Is Just a
Chair of Bowlies

Any day is sunnier
that's brightened by a smile . . .

EVERYONE
NEEDS THEIR OWN
SPOT.
· ROBERT WHALEM ·

Any friendship blossoms
if it's tended to with style . . .

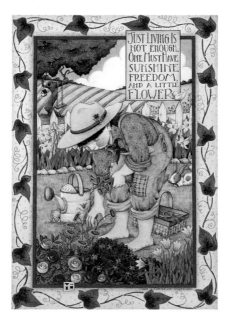

JUST LIVING IS
NOT ENOUGH.
ONE MUST HAVE
SUNSHINE,
FREEDOM,
AND A LITTLE
FLOWER.

HANS CHRISTIAN ANDERSEN

Any landscape's fresher
from a broader
point of view . . .

THE REAL VOYAGE OF
DISCOVERY CONSISTS
NOT IN SEEKING
NEW LANDSCAPES
BUT IN HAVING
NEW EYES.

MARCEL PROUST

Any learning's richer
when it's multiplied by two.

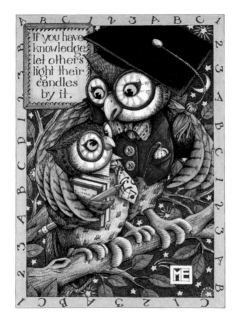

If you have knowledge, let others light their candles by it.

When we find frustration
in our everyday routine . . .

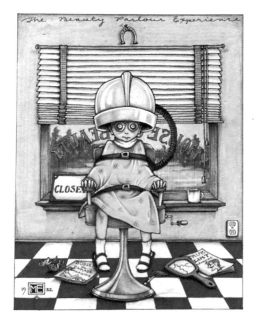

The Beauty Parlour Experience

. . . time with Mother Nature
keeps us settled
and serene.

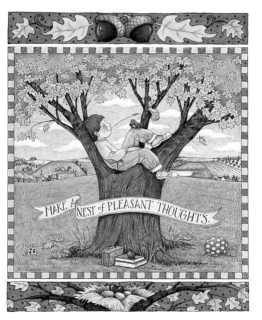

MAKE A NEST of PLEASANT THOUGHTS.

Spending quiet hours alone
can be a luxury . . .

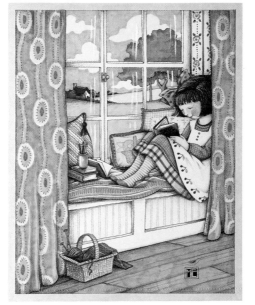

. . . that helps us
gain perspective
and achieve tranquility.

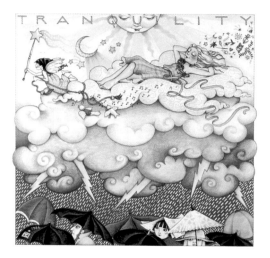

Seeing things more clearly
somehow helps the time
fly by—

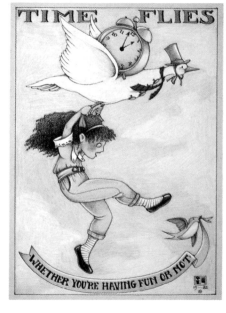

Sometimes all that's needed
is the willingness to try!

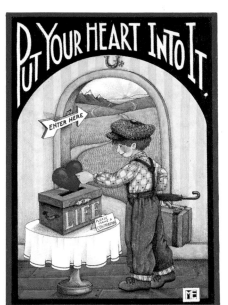

Being glad for what we've got
renews our confidence . . .

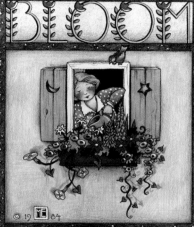

BLOOM

WHERE YOU'RE PLANTED

. . . and standing up
for what we think
can make a difference!

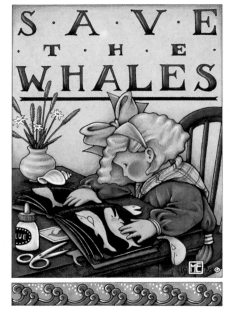

When we're gentle
with ourselves
we learn the subtle art . . .

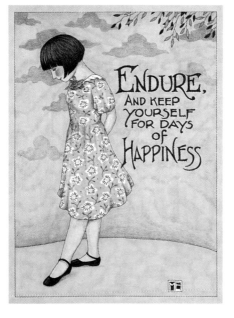

ENDURE,
AND KEEP
YOURSELF
FOR DAYS
OF
HAPPINESS

. . . of cultivating day by day
a warm and caring heart.

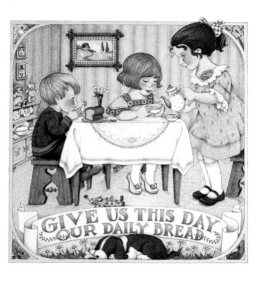

GIVE US THIS DAY
OUR DAILY BREAD

Pushing our own clouds away
helps us to understand . . .

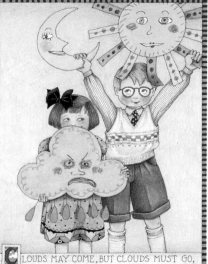

CLOUDS MAY COME, BUT CLOUDS MUST GO,
AND THEY HAVE A SILVER LINING,
FOR BEYOND THEM ALL, YOU KNOW,
THE SUN OR MOON IS SHINING.

. . . the lives of those
less fortunate
who need a helping hand.

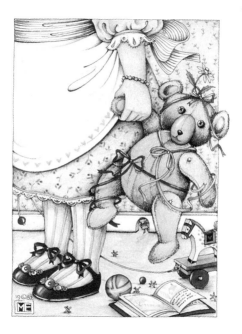

If we lose direction . . .

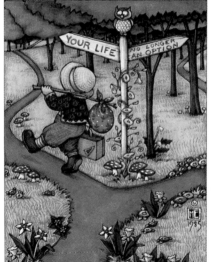

. . . or are sometimes
feeling low . . .

. . . we should concentrate
on others
and try to let them know . . .

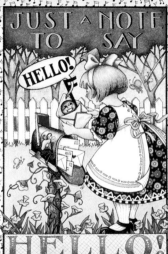

. . . for every goodness given
returns a hundred fold . . .

NOTHING IS SO STRONG AS GENTLENESS; NOTHING SO GENTLE AS REAL STRENGTH.

FRANCIS DE SALES

. . . and no one knows the limit
of the joy
a heart can hold!

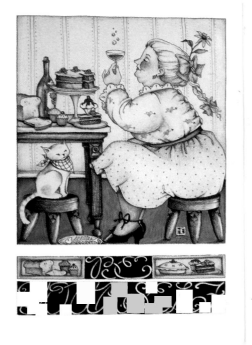